ANIMALS AT SEA

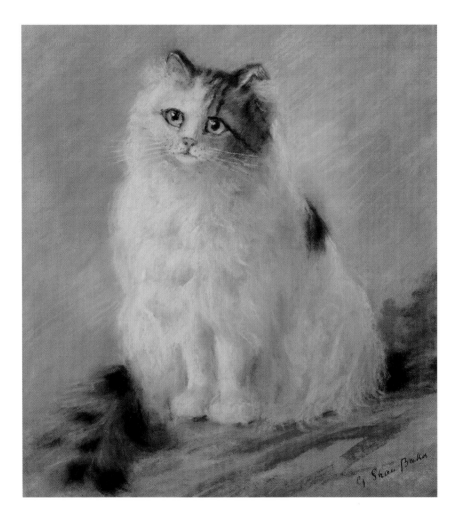

LIZA VERITY

Animals at Sea

First published in 2004 by the
National Maritime Museum, Greenwich, London SE10 9NF

ISBN 0 948065 56 7

Commissioned by Rachel Giles
Project managed by Eleanor Dryden
Editorial by Alison Moss
Design by Peter Ward
Production by Susan Sutterby

Strange that all this time I have forgotten our cow, our greatest friend, supplying the admiral and ourselves, morning and evening, with milk, and occasionally even the midshipmen. She embarked at Portsmouth, a very pretty little Alderney; she never had a calf; and considering the variety of food she had in harbour, clover, banana stems (very succulent) and other rich green substances – then at sea, as this supply failed, hay, bread, dust, pea-soup! and above all, her pint of grog . . .

Captain J. H. Boteler RN, c. 1819

ACKNOWLEDGEMENTS

The author would like to thank the following for their help:
David Hodge, Darren Leigh, the NMM Library and Manuscript Department,
Rachel Giles, Eli Dryden and Christopher Gray.

PICTURE ACKNOWLEDGEMENTS

The following are NMM photographic references.
Pictures may be ordered from the Picture Library, National Maritime Museum,
Greenwich, London, SE10 9NF (tel. 020 8312 6600). The photograph on page 99
is from the Imperial War Museum's collection (OWIL25488) and grateful
acknowledgement is made to their Trustees for permission
to reproduce it in this book.

Page 2 PT2743; *7* C4505-2; *8* N61223-3; *13* N23193; *14* PT2960; *17* D3473; *19* 7010;
20 PAH7962; *23* C5511; *24* 59-656; *27* 59-293; *29* N24261; *30* C4505-1; *33* A7422-4;
35 D0048-17 (D48-Q); *36* 3667; *38* PT2743; *41* P7392; *43* P49739; *45* P7390; *47* P39590;
48 D3191; *51* P7388; *52* E7342; *55* P7387; *56* P7473; *59* P7537; *61* F1225; *62* E2055;
65 C3399; *66* P49416; *69* P28232; *71* P47608; *72* P38593; *74* P7389; *77* F2476;
78 P7946; *81* PT2961; *83* P7927; *85* P7926; *86* P7393; *89* F2477; *91* 7948;
93 BHC1531; *95* BHC4242; *96* N61247; *101* N22686; *102* E9680;
105 58-6328; *107* 58-4309; *109* 58-4626; *111* P7391.

The photograph on page 8 shows the Second Mate, the Master, the First Mate and
the ship's dog, on board the *Grace Harwar*, 1929.

Some of the images in this book may appear a little blurred. This is an
authentic characteristic of the negatives, that will hopefully not detract from
your enjoyment of the book.

CONTENTS

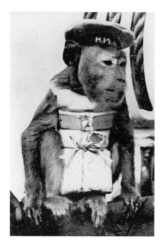

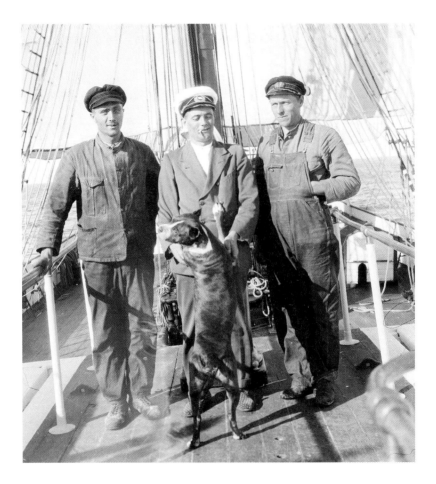

INTRODUCTION

ANIMALS OF ALL KINDS were carried on ships until well into the twentieth century at which time they were banned because of the fear of rabies. In the eighteenth and nineteenth centuries, ships would carry livestock as a source of fresh meat. One Royal Navy ship sailed to the East Indies in 1764 with a goat, a sow in pig, six-and-a-half dozen hens and thirteen ducks on board. There were drawbacks to this practice: pigs were such cheerful creatures that one skipper remarked, 'you get too partial towards them and feel after dinner sometimes as though you have eaten an old messmate'. Before a naval engagement at sea, all the livestock would usually be thrown overboard but during the battle of Trafalgar a cockerel from *Colossus* survived, perching on the captain's shoulder and crowing loudly to the cheers of the crew.

Pets and animal mascots have always been popular with sailors – dogs and cats were the most common on board but monkeys, parrots and bears were also to be found and there are many references in journals and diaries to favourite pets. Matthew Flinders wrote an essay about his cat Trim, who accompanied the explorer on four voyages and endured seven years of captivity with him on the island of Mauritius. Nineteenth-century autobiographies contain many anecdotes relating to animals. Admiral Sir Dudley St Chair recalled that early in his career his ship acquired a Syrian bear.

> Once when the admiral came up to Sunday divisions he found the bear on the poop sunning himself lying asleep. He stirred him with his foot

and said 'Good old Bob!' upon which the bear sprang up, seized the admiral, and threw him against the standard compass. The Yeoman of Signals dashed at the bear, hit him over the nose with a telescope, and the bear dropped the admiral and sprang for the Yeoman.

Needless to say when the bear later fell over board, the crew was not allowed to rescue him.

Interest in animals was not confined to the British. During their epic voyage half way around the world to confront the Japanese at Tsushima in 1905, Russian naval officers collected crocodiles, lemurs and chameleons from the many ports on the way. Captain Yegoriev of the *Aurora* (the ship is still to be seen in St Petersburg) became inordinately fond of a python, which would coil up next to him in his cabin, and instructed the ship's doctor to feed meat to the snake, sometimes laced with brandy.

In addition to companionship, some animals had a practical role on board. White mice were carried on early submarines to alert the crew to any escaping petrol fumes by their squeaking, but apparently were so well fed by the sailors that they spent their service careers comatose.

During the First World War when submarine warfare was in its infancy, one of the more bizarre ideas put forward was to employ sea lions to track U-boats. Training was carried out at the swimming baths in Glasgow and sea trials involving the sea lions Queenie and Billiken took place with the submarine *C5* in the Solent. However, the animals turned out to be more interested in chasing herring than U-boats and the project was abandoned. Along the same lines, Admiral Sir Frederick Inglefield was inspired to suggest that U-boats could be incapacitated by seagulls trained to defecate on periscopes.

Pigeons were used by navies of many countries to carry messages in both World Wars. An Italian naval officer wrote, possibly with fellow feeling, 'Pigeons, like other land animals generally suffer from seasickness, although they may not always give manifest signs of it except by loss of cheerfulness and vivacity'. The Dickin Medal, the animals' Victoria Cross, has been awarded to more of these useful birds than any other species. The medal, which was instituted in 1943, has also been awarded to twenty-four dogs, three horses and one cat. The cat was Simon of HMS *Amethyst*, in action against the Chinese communists in the Yangtse river in 1949. Despite injuries from shelling, Simon continued to hunt the rats that were depleting the ship's stores. He was commended for the medal by Lieutenant Commander Kerans. However, Admiral Sir Peter Berger, who was navigating lieutenant on the *Amethyst* at the time, confessed that he had '. . . hated the bloody thing'.

Nevertheless, animals throughout the ages have demonstrated considerable courage and loyalty and have given much consolation to their sailor companions. As Admiral Lord Collingwood's eulogy to his dog Bounce in 1809 testifies:

> You will be sorry to hear my poor dog Bounce is dead. I am afraid
> he fell overboard in the night. He is a great loss to me. I have few
> comforts, but he was one, for he loved me. Everybody sorrows for him.
> He was wiser than [many] who hold their heads higher, and was grateful
> [to those] who were kind to him.

I

Trotsky the bear being transferred to HMS Ajax *from the* Emperor of India, *1921*

After the Russian Revolution in 1917, the Royal Navy was sent to support the White armies who were fighting the Bolsheviks for control of the country. During this conflict a detachment of the Royal Marine Light Infantry helped rescue a party of White Russians from Odessa and were presented with a bear cub as thanks. Quickly named Trotsky, he joined the crew of HMS *Ajax* and lived happily on the ship, being kept in order, it is said, by the ship's dog. Trotsky would often jump ship looking for food and this proved his undoing. Sadly he was shot dead by a marine sentry when he wandered too near a rifle range at Malta Dockyard in 1921.

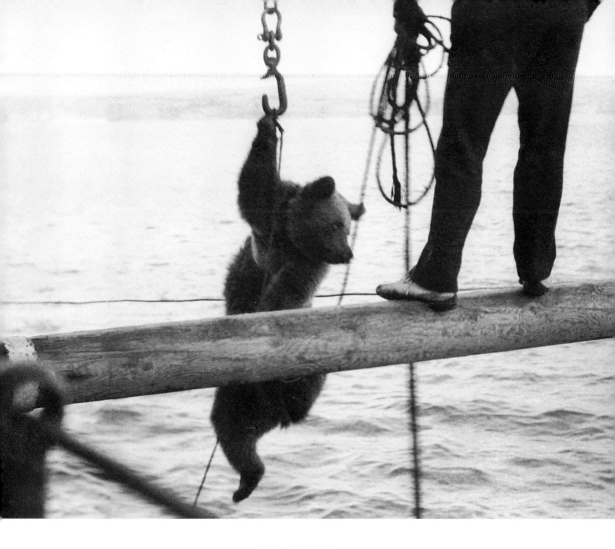

THE ANIMALS

13

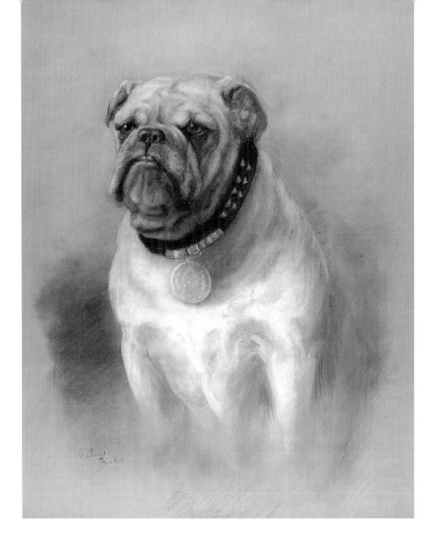

ANIMALS AT SEA

14

2

Peggy, bulldog mascot of HMS Iron Duke

Peggy entered the Royal Navy as a puppy in 1915 and joined the battleship *Iron Duke*, Admiral Jellicoe's flagship at the Battle of Jutland the following year. She was a playful dog. One of the crew recalled that every morning while they were exercising as the band played, Peggy would suddenly hurl herself at an unfortunate rating. The sailor would fall down and Peggy would waddle back to her vantage point under the muzzle of a gun turret. This portrait was painted in 1919 by Georgina Shaw Baker while Peggy was ashore for a year – the proceeds from the sale of the painting went to St Bartholomew's Hospital. She rejoined HMS *Iron Duke* but in 1923 became ill, 'remaining propped up by pillows for several days', until she died and was given a sailor's burial at sea.

3

Oscar, cat mascot of the Bismarck

Oscar survived the sinking of the German battleship *Bismarck* in 1941 and was rescued by the British Tribal-class destroyer HMS *Cossack*. When the *Cossack* was herself sunk in October 1941, Oscar was transferred to the aircraft carrier *Ark Royal*, and after she was torpedoed, he was again rescued, this time from a floating plank. His portrait, which is also by Georgina Shaw Baker, seems to illustrate this. Georgina Shaw Baker painted many animals that had gained distinction in both World Wars. Five of her pastels are in the National Maritime Museum's collection. Oscar spent the rest of his nine lives peacefully in a Sailors' Home in Belfast.

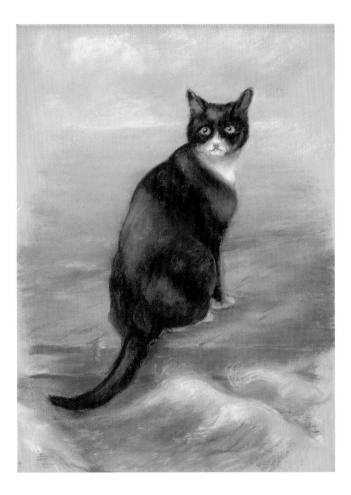

THE ANIMALS

17

4

Three collies on the poop of the Cutty Sark

The last captain of the famous clipper ship under British owner-ship was Richard Woodget, who commanded her from 1885 to the end of her wool-carrying days in 1895. He was known for his love of animals and, in particular, for his 'magnificent collies', which he bred on board the ship. Woodget, who was clearly a man of varied interests, also learned to ride a bicycle in the ship's hold and was a keen photographer. It is said that on one occasion, when rounding Cape Horn in a storm, the crew wanted to abandon ship. Woodget disabled the lifeboats with an axe, took his pistol, loaded it and said, 'Now my men, we will sink or swim together'. Woodget retired to a farm in his native Norfolk where he bred more of his beloved collies, dying at the age of eighty-two in 1928.

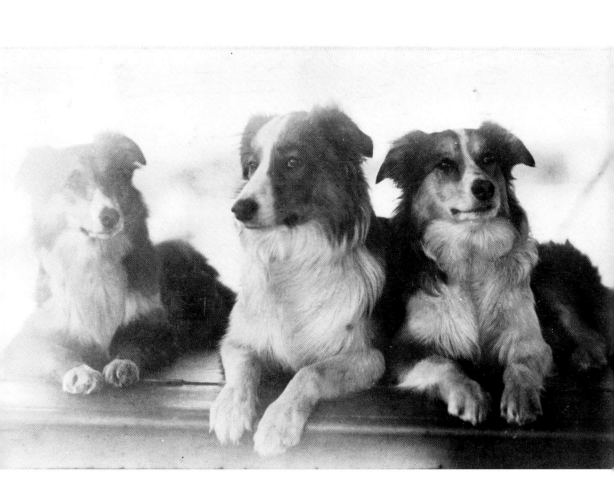

THE ANIMALS

19

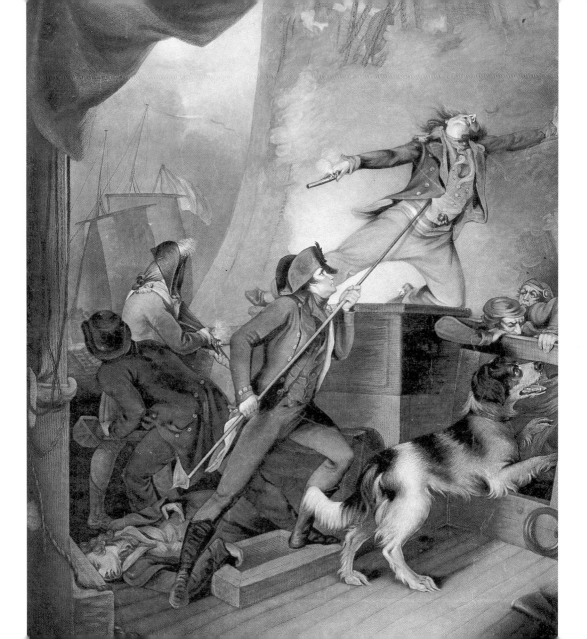

5

Newfoundland dog on board the Wolverine, *1799*

This print depicts Captain Lewis Mortlock and his favourite Newfoundland dog engaged in a spirited defence of their ship against two French privateers, the *Ruse* and the *Furet*. Although the *Wolverine* carried only seventy men, they succeeded in fighting off the enemy. The *Naval Chronicle* reported, '. . . many Frenchmen were actually on board the *Wolverine* but were killed by the gallantry and exertion of Captain Mortlock and his brave officers and men'. One of the French captains 'presented a pistol to Captain Mortlock's face, which fortunately missed fire. He again cocked his pistol but seemed in a moment struck with panic, and Captain Mortlock plunged his half pike into his body before he could fire and he fell overboard'. Tragically, Mortlock was shot and killed as the French made their escape, but the dog escaped without injury.

6

Admiral Lord Charles Beresford with bulldog

Admirals and their bulldogs seem to complement one another. This photograph in the *Navy and Army Illustrated* is captioned, 'Our Most Popular Admiral . . . and his inseparable companion, a brindled bull, is a gem amongst dogs'. However, Admiral Beresford and his bulldog were not popular with everyone. There was no love lost between Beresford and Lord Louis Mountbatten, who later wrote, 'His flagship was like the palace of some medieval tyrant, and he liked to have on board his wife, his motor car and his fat pet bulldog, behind whom there followed at all times a sailor with a dustpan and brush'.

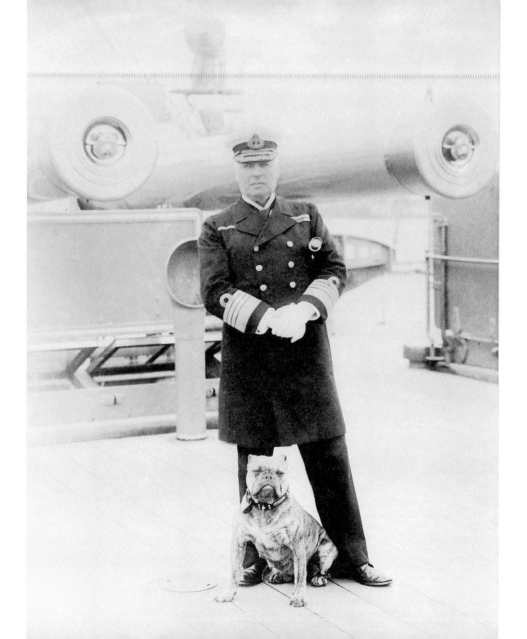

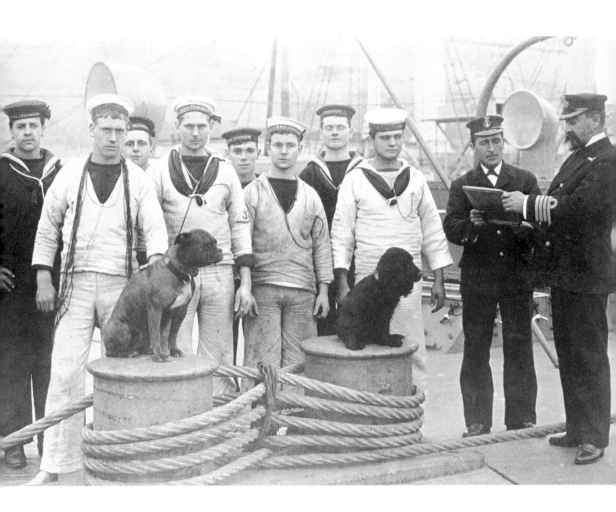

ANIMALS AT SEA

24

7

A quarterdeck scene on board HMS Trafalgar *at Malta, 1897*

The captain appears to be mustering the boxer and spaniel together with a party of sailors for work in the ship or the dockyard. The men in the front row are wearing canvas working suits and the officer is collecting a slate with a message just received from the bridge. The battleship HMS *Trafalgar* was commissioned in 1890 and served with the Mediterranean Fleet, spending seven years based at Malta.

8

A bloodhound on board HMS Revenge, *1896*

This dignified dog belonged to Lieutenant William C. M. Nicholson of HMS *Revenge,* a pre-dreadnought battleship launched in 1892. Nicholson was a torpedo specialist, and a typical entry from a junior officer's logbook from the *Revenge* reads:

> January 31st 1896
> 8 00am Fired one whitehead torpedo.
> 9 30am Exercised general quarters and fired two more
> whitehead torpedoes. Received 1326 lbs of beef and
> 420 lbs vegetables. Gave special leave to starboard watch.

Nicholson rose to become an admiral and Third Sea Lord. He died in 1932.

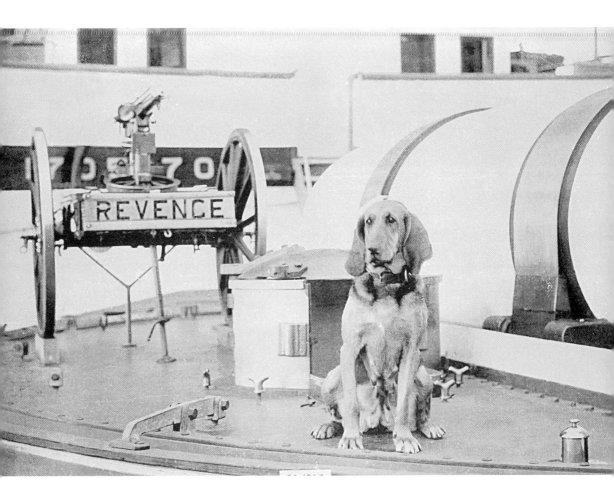

THE ANIMALS

27

9

Dog on board HMS Laforey, *1915–16*

The *Laforey*, an 'L'-class destroyer, was launched in 1913. In 1914 she joined the Harwich Force as part of the 3rd Destroyer Flotilla. During the First World War the ship took part in the Battle of Heligoland Bight in 1914 and the Dogger Bank action in 1915. On 1 May 1915 she was part of a fleet that sank two German destroyers off the North Hinder Light Vessel, and on 26 October 1916 she was sent with three other destroyers to help counter the German destroyer raid through the Dover Strait.

This photograph shows two petty officers and two ratings with the ship's mascot. Not all mascots belonging to the Harwich flotilla were living creatures. The captain of a submarine that had unsuccessfully fired seven torpedoes at enemy ships discovered a member of the crew drowning a teddy bear, the ship's mascot, in a bucket of sea water hoping to change their luck.

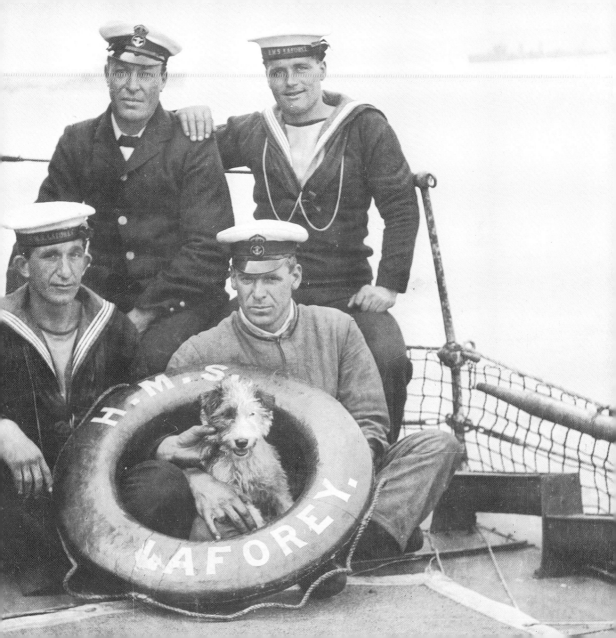

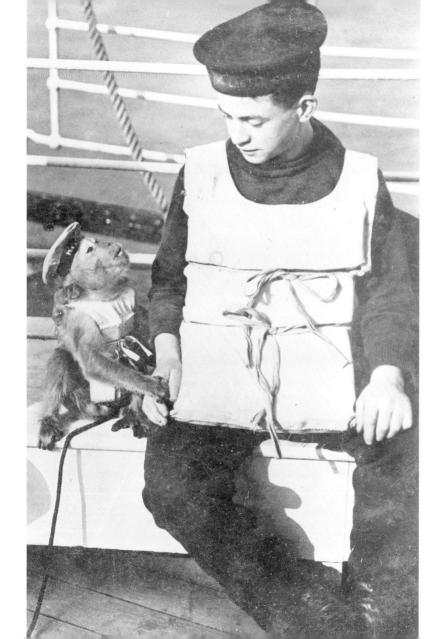

Ship's mascot Jacko at Boat Drill

Monkeys have always been popular pets with sailors, although they can be very wild and destructive. However, Jacko is seen here looking very docile in his life jacket with a boy sailor on board the *Garth Castle* about 1914. The *Garth Castle* belonged to the Union Castle Line and for the duration of the First World War served as a naval hospital ship.

Captain John Harvey Boteler, who wrote his recollections of his life at sea, remembered a monkey on board HMS *Sceptre* in 1812. The animal was brought before the master-at-arms for stealing cartridges from the ship's store. Despite the captain's protestations that 'he would not have the monkey hurt, it was in the nature of the creature to be mischievous', the monkey was duly punished by having his whiskers singed with black powder.

Sailors with pets — a monkey, a dog and caged birds — on the Oopack, about 1900

This photograph shows a variety of pets favoured by sailors, including the ubiquitous monkey. The *Oopack* was a merchant vessel originally owned by the China Mutual Steamship Company and later by the Blue Funnel Line. Her career ended on 14 October 1918 when she was torpedoed and sunk by submarine *UB68* commanded by Lieutenant Commander (later Admiral) Karl Dönitz. Later the same day the U-boat herself surrendered to HMS *Snapdragon*. Survivors, including Dönitz wearing only a shirt, underclothes and one sock, were taken on board the *Snapdragon* to be greeted by the rescued crew from the *Oopack*. The animals in this photograph were, of course, long gone by then.

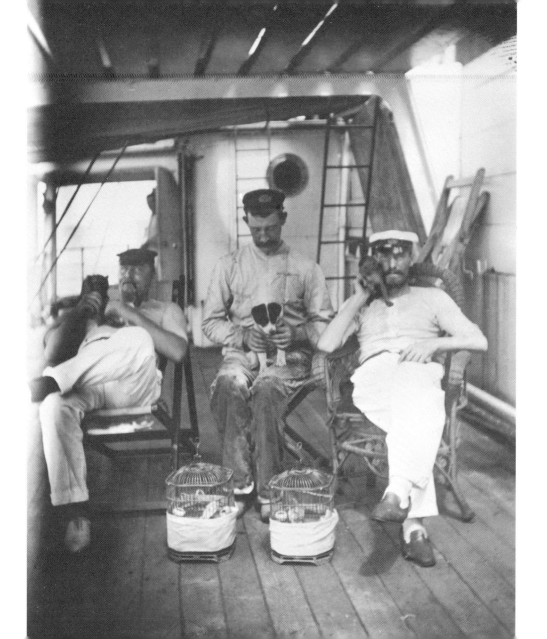

12

Captain Bray and Ollie on board the Holt Hill, *1910–14*

Henry James Bray was the master of the four-masted barque *Holt Hill* from 1910. During the First World War Bray served as a lieutenant in the Royal Naval Reserve and in 1916, while commanding the armed trawler *Searanger*, helped to sink the German submarine *U74* which was on a mine-laying expedition in the Firth of Forth. Bray was given one of the highest gallantry awards – the Distinguished Service Cross – for this action. He is shown here in the centre of the photograph.

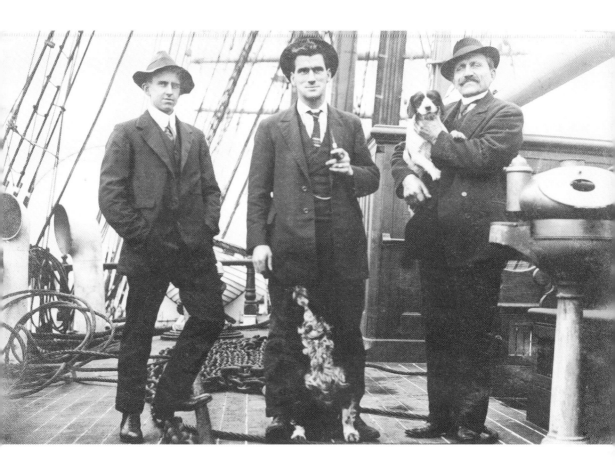

THE ANIMALS

35

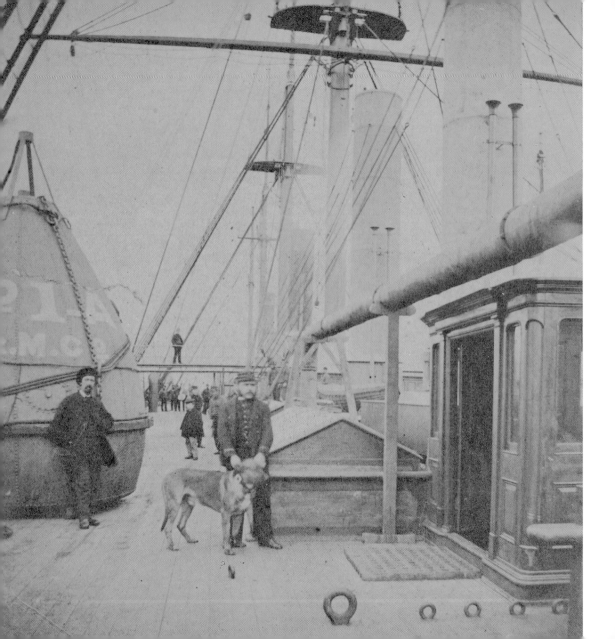

13

Captain Halpin and his dog on the Great Eastern, *1873*

Robert Halpin was born in Wicklow in 1836 and went to sea at the age of ten, first serving on board the Whitehaven brig the *Briton*. During the American Civil War, Halpin was master of the Confederate gun-runner *Eugenie*. In 1869 he was appointed master of the *Great Eastern*, employed in laying cables from Brest to Newfoundland and from Bombay to Aden and Suez.

Designed by Isambard Kingdom Brunel, the *Great Eastern* was launched in 1858. She was originally intended to carry troops and passengers to India or Australia but actually served only briefly as a transatlantic liner before being converted to a cable-layer.

Halpin is shown here with his mastiff Harold, described as 'his sole companion' on board the *Great Eastern*.

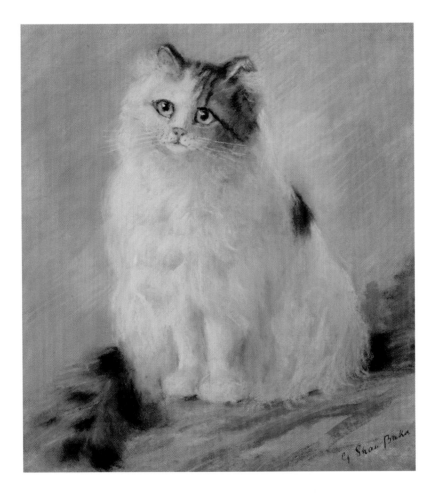

ANIMALS AT SEA

14

Jimmy, mascot of HMS Renown

Jimmy was a large tortoiseshell cat adopted by a naval cook when his owner, a wounded Australian soldier, was no longer able to care for him. Attached to the battleship HMS *King George V*, Jimmy sailed with his new owner at the head of the Grand Fleet to take part in the Battle of Jutland, 31 May 1916. He was on deck when the ship came in range of enemy guns, and shrapnel from an exploding shell badly damaged his left ear. In September of the same year Jimmy was transferred to the battle-cruiser HMS *Renown* where, more often than not, he was found in the galley. Jimmy had this portrait painted of him by Georgina Shaw Baker, and ended his days in a Cats' Home in Chelsea, where he died in 1924.

15

Mascot, HMS Renown

The British bulldog wearing a sailor's cap is a familiar symbol of the pugnacious spirit of the Royal Navy. This spirit is epitomized by the career of HMS *Renown*, which took part in hunting the German battleship *Bismarck* in 1941 and in both the Malta and Arctic convoys. During the Arctic convoys, *Renown*'s gunnery lieutenant had a small sheepdog on board. Although the blast from the firing of the ship's guns would knock the dog from one side of the ship to the other, he was unperturbed by gunfire and indeed hated to go ashore.

"SAILORS DONT CARE"

H.M.S. RENOWN

Poor Boss

After hearing for the 100th time "What do you think of Our Harbour?"

16

Wallaby on board HMS Renown

This photograph, also on board *Renown*, is assumed to have been taken during her 1920 tour of Australia and New Zealand – hence the arrival of the baby wallaby. HMS *Hood*, another battle-cruiser engaged in a cruise round the world in the 1920s, was presented with a kiwi-bird, which sadly did not survive. Lieutenant Benstead wrote in his book *Round the World with the Battlecruisers*, 'It is popularly supposed that the poor bird's death was hastened by chronic neuralgia contracted through his spirited but unsuccessful endeavour to peck holes in armour plate. There is, however, no evidence of this'.

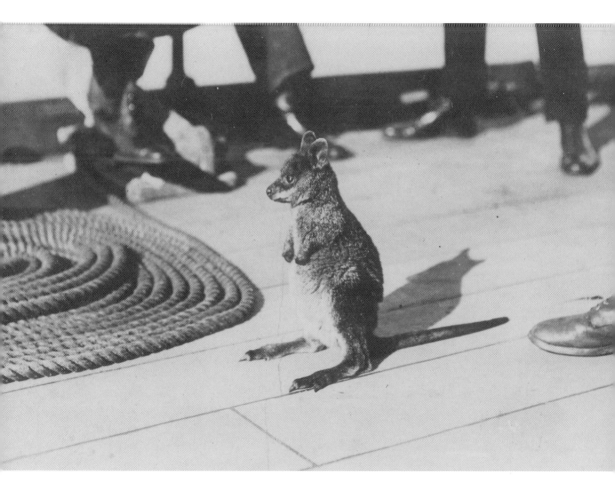

17

HRH Edward, Prince of Wales, and a terrier on board HMS Hindustan

The Prince of Wales joined the *Hindustan* in 1911. As a midshipman he is wearing a uniform with white patches on the collar (the patch still indicates the rank of midshipman today). Shortly after his arrival on the ship, the Prince was discovered in the wardroom ensconced in an armchair smoking a cigarette, whereupon he was given short shrift by the irate commander, Captain Henry Campbell. The wardroom was strictly for senior officers only and the Prince was to be given no favours. Nevertheless, not surprisingly, he acquitted himself well while serving on the ship and was described by one of the officers as a 'live wire'.

The fox terrier in the photograph looks remarkably like Caesar, the favourite dog of Edward VII, who outlived his master and died in 1914. The Prince of Wales was also very fond of dogs, particularly cairn terriers, although following his marriage to Mrs Simpson, pugs became his preferred pets.

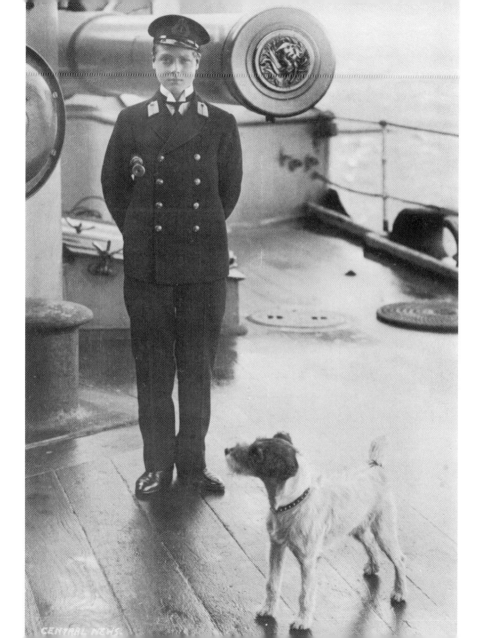

18

Bruin, the bear from HMS Rodney, *in a group photograph at Yokohama, 1869*

July 8 1869

To luncheon yesterday on board *Ocean*. Afterwards to *Rodney*, taking children. She being ordered home, had all sorts of live animals. Among them were two bears who had the run of the ship. In the summer months hammocks were little used; bears lay where they like, the men using them as pillows. Each bear would accommodate ten or a dozen at a time.

This quote is taken from the memoirs of Admiral of the Fleet Sir Henry Keppel, who commanded the China Station 1866–69; HMS *Rodney* was his flagship. Bruin the bear can be seen at the centre of the photograph.

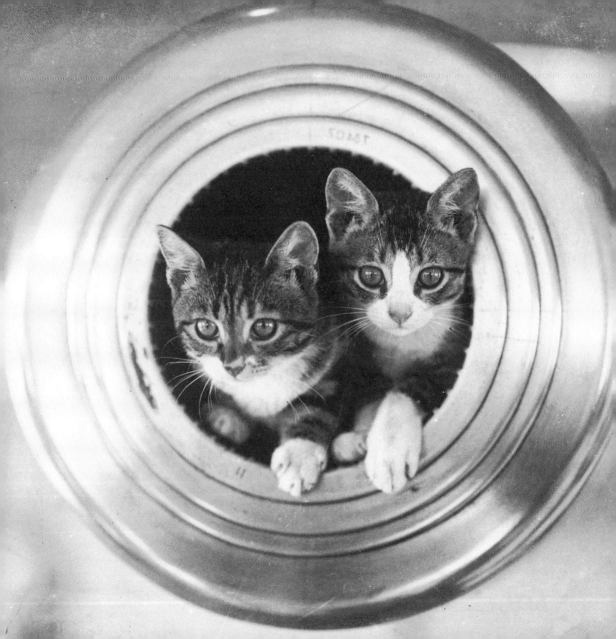

19

The ship's cats, HMS Hawkins, *1919–21*

From 1919 to 1928 the cruiser HMS *Hawkins* served as the flagship of the Commander-in-Chief on the China Station. A ship's magazine was produced on board between 1919 and 1921 and among reports of the China Squadron Regatta, announcements of dances, and dark warnings on the evils of Bolshevism was written the following poem to the ship's cat:

> Tibby now no more, alas—
> Rated 'Ratter Second Class'
> To the good ship 'Appy 'Awkins
> Did one day after many stalkings
> From galley, by the starboard passage
> Appropriate a cast-off sausage.

Goat, HMS Irresistible

One of the earliest known regimental mascots was a goat, which stood by the Royal Welch Fusiliers at the Battle of Bunker Hill on 17 June 1775. Originally goats were kept by sailors at sea to provide milk and meat on long voyages, but later they became popular as mascots. In the nineteenth century, the USS *New York* carried a goat called El Cid.

Little is known about the goat pictured here in a very smart coat but the photograph probably dates from the early twentieth century when the *Irresistible* was based in Malta. The 1920s battleship, *Barham,* also carried a goat mascot called Bill, whose favourite food was cigarettes and paint from the anchor chains.

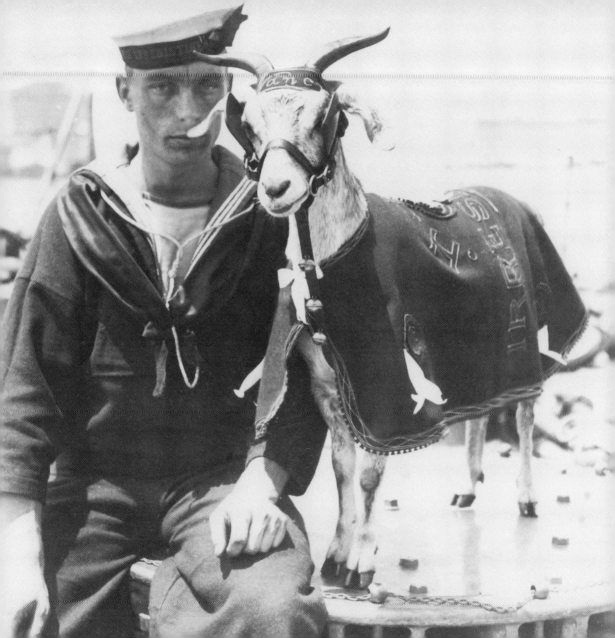

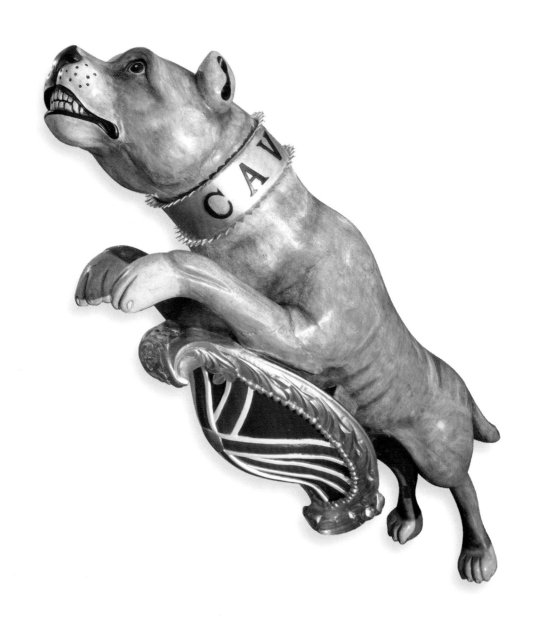

'Beware of the Dog' figurehead, HMS Bulldog

Figureheads are one of the most evocative relics of the sailing navy. Animals were a consistently popular choice, the lion being the usual figurehead on early warships. In 1727, however, the Navy Board wrote to the Admiralty, 'that different figures for the head may be more properly adapted for ornament and made lighter than the figure of a lion, especially for small ships and be equally as cheap'. This beautifully carved bulldog was made for the paddle sloop of the same name launched in 1845.

22

Black cat and spaniel, HMS Barham, *about 1916*

In 1807, Admiral Fremantle wrote in his diary, 'I shall now go to bed, my poor little dog sleeps with me and is my friend and companion, my cat is quite tame and they appear quite friendly, eating out of the same plate . . .'

As this photograph shows, dogs and cats can co-exist happily on board ships. However, Bonzo, the bulldog of Vice-Admiral Sir John Kelly, who commanded HMS *Barham* in the 1920s, was not quite so accommodating. He got into trouble for pushing the ship's cat overboard and biting the bugler.

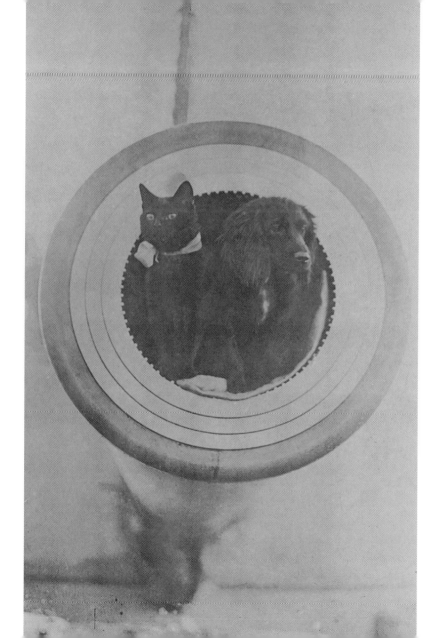

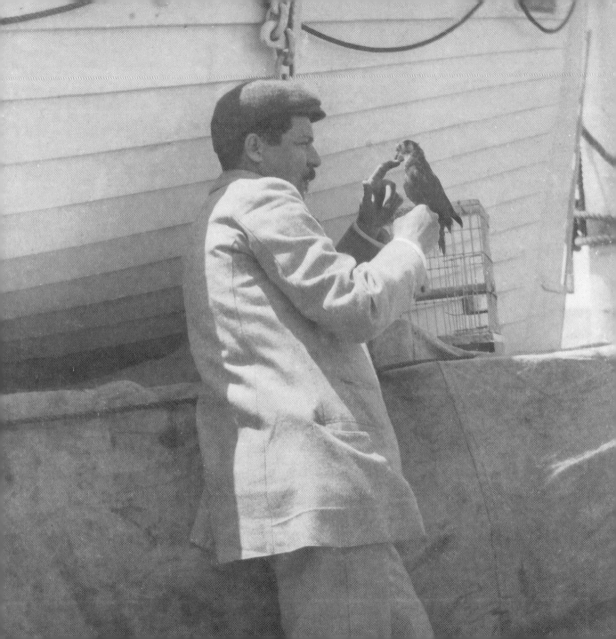

23

Teaching parrots swear words on board the Raglan Castle, *about 1900*

Although they were originally brought back as part of the lucrative trade in exotic pets for the various royal menageries in Europe, the ability of parrots to learn tricks and mimic the human voice has endeared them to sailors as good companions.

24

Scot at his bath attended by his faithful servant 'Lamps'

Another photograph from the Union Castle liner *Raglan Castle* showing Scot the collie, who belonged to the master of the ship, Captain Bryan.

Little is known about Bryan other than that he was born in 1853 in South Africa and worked for the Union Castle Line all his life until his retirement. He died in 1930. The *Raglan Castle* was sold to the Russian navy and was used as a storeship during the Russo-Japanese war in 1905.

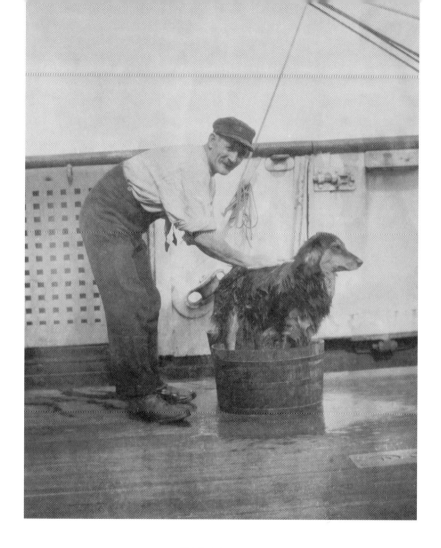

THE ANIMALS

59

25

Able Seaman Just Nuisance

The only dog to be officially enlisted into the Royal Navy, Just Nuisance was issued with a service certificate that stated that his trade was 'Bonecrusher' and religion was 'Scrounger'. He never went to sea but instead remained on the naval base at Simonstown, South Africa, from 1939 until 1944. Said to be profoundly patriotic, Just Nuisance would rise to his feet at the first bar of 'God Save the King'. He was always steadfastly 'lower deck', just about tolerating petty officers. When Just Nuisance died in 1944 he was buried with full naval honours.

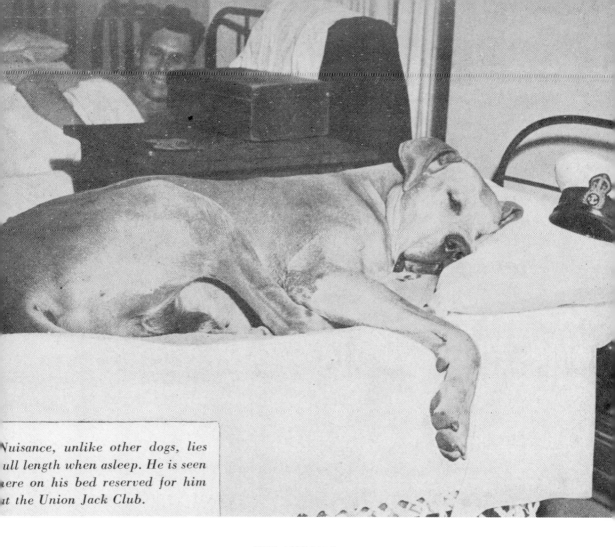

Nuisance, unlike other dogs, lies full length when asleep. He is seen here on his bed reserved for him at the Union Jack Club.

THE ANIMALS

61

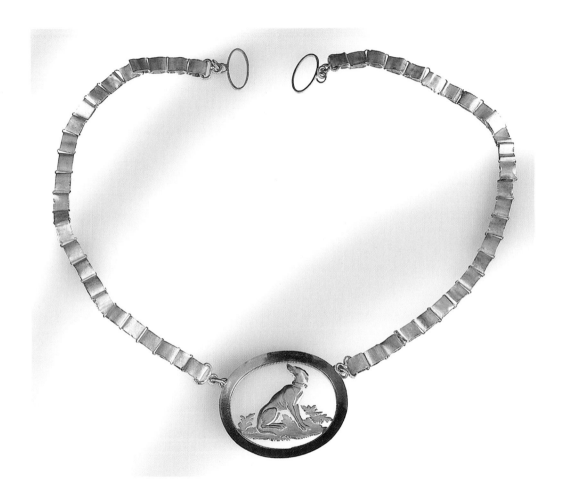

ANIMALS AT SEA

62

26

Gold necklace with silhouette of a greyhound

On 21 October 1803, exactly two years before the Battle of Trafalgar, Admiral Horatio Nelson wrote to his daughter Horatia, aged two-and a-half, from HMS *Victory* off Toulon:

> My dear Child
> Receive this first letter from your most affectionate Father.
> If I live, it will be my pride to see you virtuously brought
> up, but if it please God to call me, I trust to Himself: in
> that case, I have left Lady H your guardian.

In 1804, the necklace in the photograph was given by Nelson to Horatia in response to her request for a dog. Nelson – like most parents – understood the inadvisability of giving pets to very small children and wrote to her, '. . . the dog I could never have promised you as we have no Dogs on board ship'.

27

Silver dog collar inscribed Nileus

Poor Nile was bought at a large dog shop in Holborn;
Mr Davison was with me. Those active dogs will not do
for the house; if he is not found and you buy another,
get a more domestic animal.

Despite or perhaps because of this collar inscribed 'Nileus, the
property of Lord Nelson', the dog was either stolen or lost, hence
this letter from Nelson to Lady Hamilton, dated 21 January 1801.
Presumably the dog was named after Nelson's famous victory at
the Battle of the Nile in 1798.

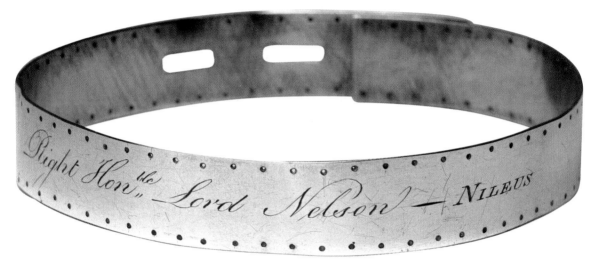

Right Hon.ᵇˡᵉ,, Lord Nelson 74—NILEUS

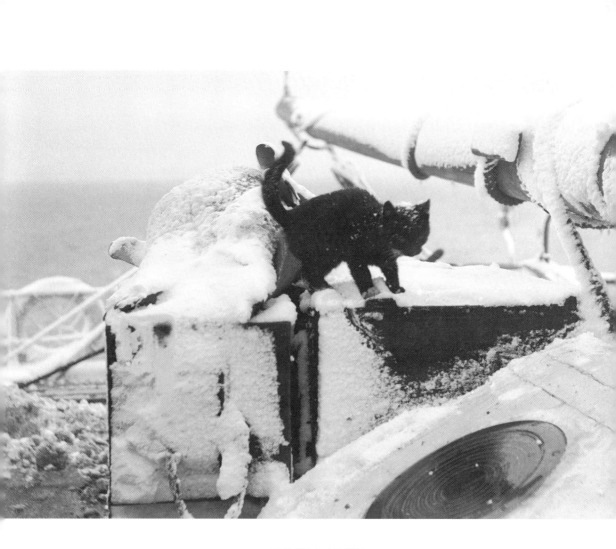

28

Cat on Steam Yacht Morning

One very cold cat. This photograph was taken on board SY *Morning*, the supply ship to Captain Robert Falcon Scott's *Discovery* on the National Antarctic Expedition 1902–04. Dogs and ponies were taken on polar expeditions to pull the sledges, and cats were carried, as on all ships, to keep down the vermin, but were also cherished as pets.

Edward Wilson, accompanying Scott on the expedition, wrote in his diary of another cat: 'The little black she-cat that has been with us the whole two years was found dead today killed by the dogs. The cat belonged to Quarterly one of the stokers, an American, and he was devoted to it'.

29

Mr P. M. Anderson and Russ on the Scotia

In November 1902 the Scottish National Antarctic Expedition led by William Spiers Bruce sailed from Troon to explore the South Pole. Their ship was the *Scotia*, a barque-rigged auxiliary whaler built in Norway. Russ, described as a 'Siberian sledge dog' caused great consternation by disappearing over a glacier when the ship had anchored in Scotia Bay. He reappeared eleven days later ravenously hungry but still refused to sleep in a cabin, preferring to curl up on an ice floe while his more effete companions – 'mongrel collies from the Falkland Islands' – stayed in the deckhouse. Anderson was one of the crew and also the ship's chief barber.

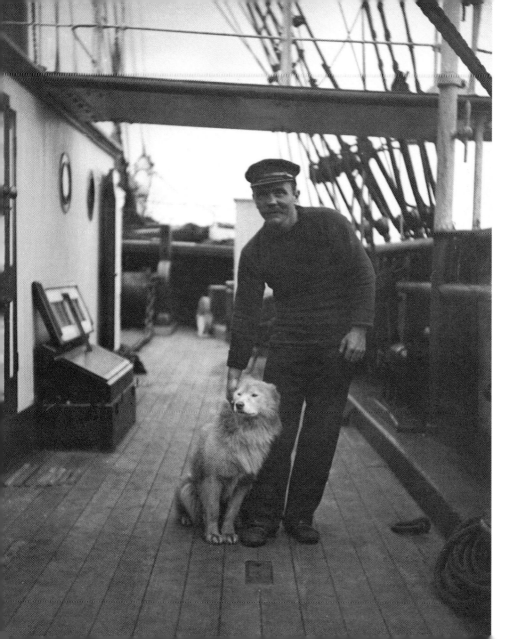

Samson, Imperial Trans-Antarctic Expedition

How dreary the frozen captivity of our life but for the dogs.
Frank Hurley, photographer on the expedition

Samson, one of the dogs taken on Sir Ernest Henry Shackleton's Imperial Trans-Antarctic Expedition of 1914–17, is seen here emerging from one of the specially built 'dogloos'. The dogs were secured by a chain that was buried into the ice, but the men made straw mattresses to make the dogs' lives more comfortable. In order to conserve supplies, all the dogs had to be shot when the *Endurance* was crushed in the ice and Shackleton and his men began their incredible journey of survival to Elephant Island.

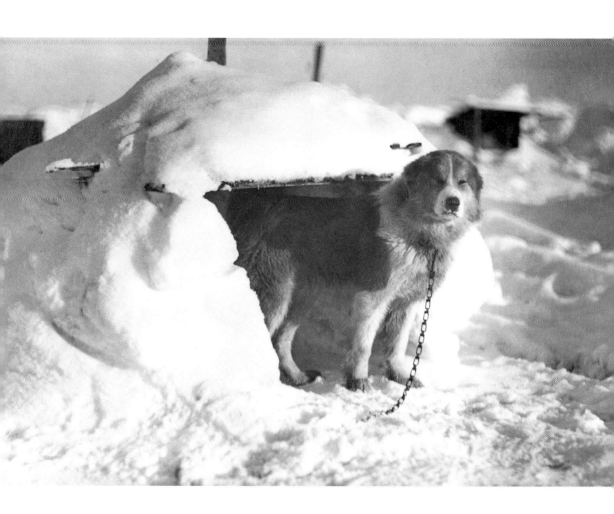

THE ANIMALS

71

Seaman on Pommern *enticing the ship's cat up one of the shrouds*

The *Pommern*, a four-masted barque, was built in 1903 by J. Reid of Greenock for German owners. By 1928 she was owned by Gustaf Erikson of Mariehamn whose ships sailed in the famous grain races bringing wheat from Australia to Britain. Eric Newby, who sailed on another Finnish barque, the *Moshulu*, in 1938, gives this graphic description of conditions on board: 'The noise was indescribable, the shrieking of the wind in the shrouds, the clanging of freeing ports and the thunder of the sea as it came over the rail like a mill race'.

The *Pommern* was presented by the Erikson family to the city of Mariehamn where she is now preserved.

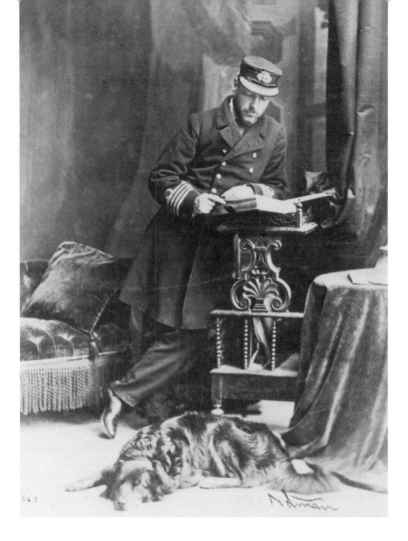

ANIMALS AT SEA

74

32

Captain Erskine of HMS Eclipse *with collie, 1873*

HMS *Eclipse* spent most of her life on the North and South American Stations and in the East Indies. She ended her life as a store hulk for mines. Her captain, John Elphinstone Erskine, had a more eventful life, however. In 1853 he published his journal of a cruise to Polynesia, in which he describes the practice of cannibalism. 'It is remarkable', he observed, 'that there is a general belief in the disagreeable flavour or saltiness of the flesh of white men'.

33

Rex, dog of HMS Tiger, about 1916

Easily the most handsome British capital ship for many years, the battle-cruiser HMS *Tiger* was known as 'one of Beatty's beautiful cats'. She took part in the Battle of Jutland on 31 May 1916 where she received twenty-one hits in all. Three battle-cruisers were blown up at Jutland causing Churchill to say later, 'they were cats with thin skins'. Her captain at Jutland, Henry Pelly, may well not have been fond of dogs, as he wrote the following when he was a boy: 'I was sent to stay with relatives who had a vicious dog. It took the opportunity of taking a small portion out of my leg'.

Pelly, who had a distinguished naval career, was later incensed when, while waiting for HMS *Tiger* to be fitted out in 1914, he was offered that symbol of cowardice, the white feather, by a 'misguided young female. I am afraid I said things to that young woman'.

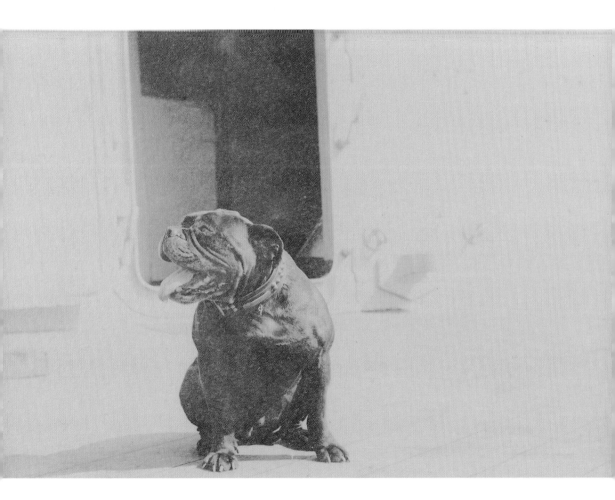

THE ANIMALS

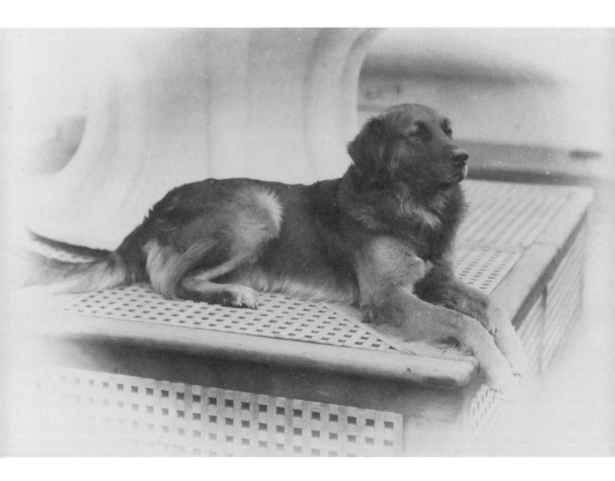

ANIMALS AT SEA

34

Monarch, owned by Lieutenant, later Admiral Sir Colin Keppel on board HMS Alexandra, *1887*

The Keppels were an illustrious naval family. Admiral of the Fleet Sir Henry Keppel was a great nephew of Admiral Augustus Keppel, 1st Viscount Keppel, who served with distinction in the Seven Years War of 1756–63. Sir Henry's son Colin also had a distinguished career, rising to the rank of Admiral. Clearly a dog lover from an early age, he wrote the following in 1872 when he was ten years old: 'My dear Father, I have bought a collar and chain for the dog. He knows me quite well now. Sometimes I buy biscuits for him. He is getting very fat and I give him exercise every day'.

35

Judy, wearing the Dickin Medal

Judy, an English pointer, began her shipboard life as the mascot of the Yangtze river-gunboat HMS *Gnat*. In 1939 she and the crew were transferred to another gunboat, HMS *Grasshopper*, where Judy was given an official action station on the bridge, alerting the crew to approaching Japanese aircraft. Despite Judy's efforts, the *Grasshopper* was bombed and sunk soon after the fall of Singapore in 1942 and she and the surviving crew spent two years in a prisoner-of-war camp in Sumatra. Judy saved the lives of several men by distracting the guards when they tried to beat prisoners and survived several attempts by the Japanese to shoot or bayonet her. After the war, she was awarded the Dickin Medal, the animal equivalent of the Victoria Cross. Judy died in Tanzania in 1950. This portrait is by Georgina Shaw Baker.

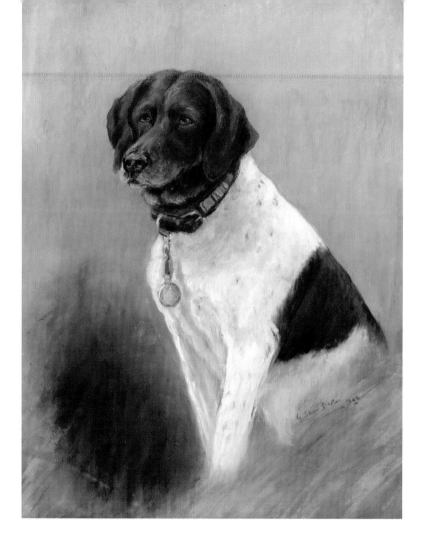

THE ANIMALS

36

Grave of Bruce, the captain's airedale of HMS Formidable, 1915

HMS *Formidable* was sunk by three torpedoes fired from *U24* on 1 January 1915 off Portland Bill. In atrocious conditions some of the men managed to make it to the shore at Lyme Regis but 780 were lost, including Captain Loxley who stayed on the bridge until the end, smoking a cigarette with his terrier Bruce by his side.

Another dog linked with the incident was Lassie, who belonged to the landlady of the Pilot Boat Inn where the dead were carried. Lassie drew attention to Seaman Cowan, who was laid on the floor for dead, by licking his face. The young man revived and Lassie was awarded two animal medals.

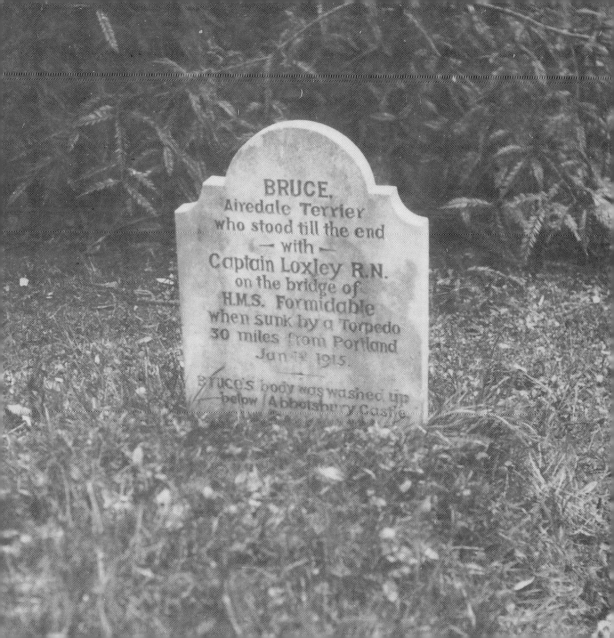

BRUCE,
Airedale Terrier
who stood till the end
— with —
Captain Loxley R.N.
on the bridge of
H.M.S. Formidable
when sunk by a Torpedo
30 miles from Portland
Jan 1st 1915.

Bruce's body was washed up
below Abbotsbury Castle.

37

Admiral Sir Percy Scott with Peter, the Eland bull mascot of HMS Good Hope, *about 1908*

Sir Percy Scott has been described as 'the father and mother of modern naval gunnery'. Born in 1853, he entered the Royal Navy at the age of thirteen and quite early in his career took a keen interest in naval gunnery. He introduced new signalling and gunnery apparatus into the Navy: his most famous invention was the Scott director system, which was a method of laying and firing several guns from one gun-sight. In 1908, after a falling out with Admirals Beresford and Fisher, Scott was put in command of a squadron of cruisers sent to South Africa. Presumably Peter, a species of antelope, was presented to the ship's company during this trip.

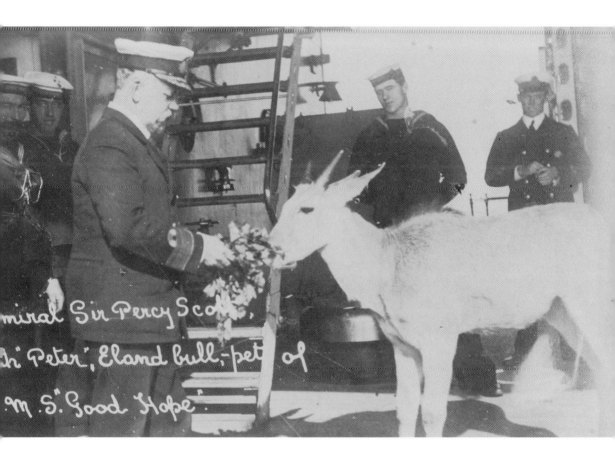

Admiral Sir Percy Scott, with "Peter", Eland bull-pet of H.M.S. "Good Hope".

38

Princess Victoria with Mac on board the Victoria and Albert III, *1909*

The '*V&A*' was built by Sir William White and launched in 1899. Initially described by Edward VII as 'simply hideous', she soon became popular with the Royal Family because of her speed and comfort. One of the daughters of Edward VII and Queen Alexandra, Princess Victoria, enjoyed many cruises in the Royal Yacht and in 1909 accompanied her parents to the Mediterranean and Denmark. Princess Victoria was a great dog lover and had the combings from her poodle knitted into a shawl. She never married and her Russian cousin, the Grand Duchess Olga, wrote, 'Poor Toria was just a glorified maid to her mother'.

39

Cushion cover of Hoskyn, the ship's cat

Embroidered by a sailor of HMS *Chester* after the Battle of Jutland, this cushion cover was presented to Surgeon Lieutenant Brownfield of the ship's medical staff. Hoskyn was not the only animal on board the ship during the battle. Sub-Lieutenant Phipps-Hornby wrote, 'The captain's bob-tailed sheepdog had also been wounded in the leg but happily not seriously'.

HMS *Chester* suffered many casualties among whom was Jack 'Boy' Cornwell who was posthumously awarded the Victoria Cross for 'standing alone at a most exposed post, quietly awaiting orders, until the end of the action, with the gun's crew dead and wounded all round him'.

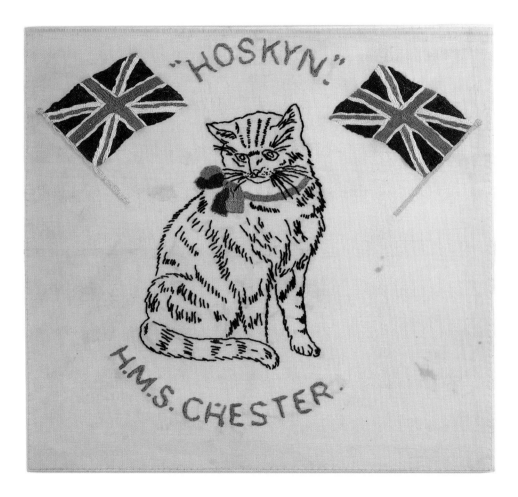

40

Mongoose, mascot of HMS Emerald, *about 1928*

Kitty the mongoose was remembered recently by the son of one of the officers who served on board HMS *Emerald* in the 1920s. He describes her as being a great favourite with the crew who used to bring snakes on board for her to eat. In February 1926, the *Emerald* sailed for the first of what were to be many cruises, which had the dual function of 'showing the flag' and dealing with minor disorders in the many islands and territories of the British Empire in the East. Kitty was acquired as the ship's mascot during this time but unfortunately did not last long. We know from the officer's recollections that she died prematurely after licking red lead paint that was used on ships to prevent corrosion.

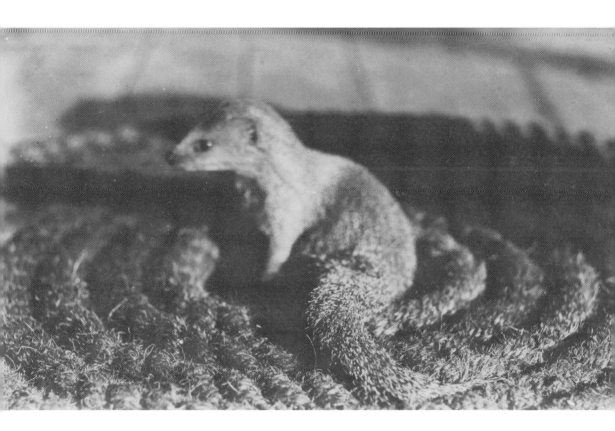

41

Scouse, mascot of HMS Exeter

HMS *Exeter* was one of the cruisers that took part in the historic Battle of the River Plate in December 1939 against the German pocket-battleship the *Admiral Graf Spee*. This action resulted in the scuttling of the battleship followed by the suicide of her captain, Hans Langsdorff. HMS *Exeter* suffered heavy damage and severe casualties but returned to a tumultuous welcome at Plymouth in February 1940. First down the gangplank was Scouse, who had survived the battle.

The ship's canary had not only managed to survive but had hatched an egg: as a shell exploded nearby her chick was born and was christened Graf Spee. The chick was later raffled to raise money for the dependants of those killed.

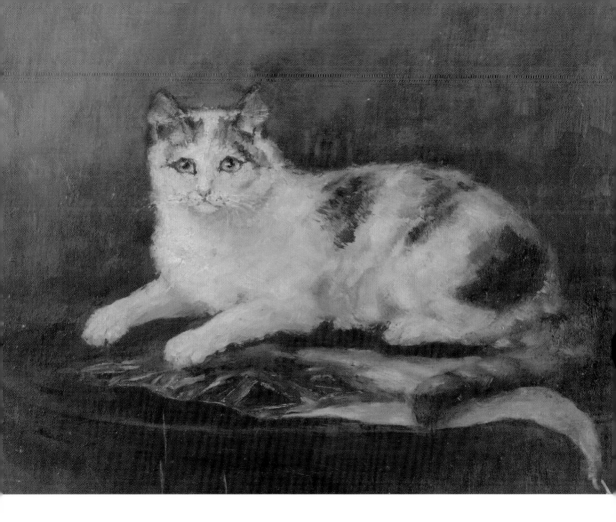

42

Naval officer with dog

Although the sitter is unidentified, it may be Captain Alexander Schomberg (1720–1804). This portrait can be dated to 1774–87 when the undress uniform as worn by this officer was in use. Dogs were often taken on board ships in the eighteenth century to be used in hunting expeditions by the officers while ashore. Joseph Banks took a greyhound and a spaniel called Lady as a gun dog when he accompanied Captain James Cook on the *Endeavour* in 1768–71. Banks wrote in his journal: '. . . and with its first dawn we set out in search of game. We walked many miles over the flats and saw four of the animals [kangaroos] two of which my greyhound fairly chased'.

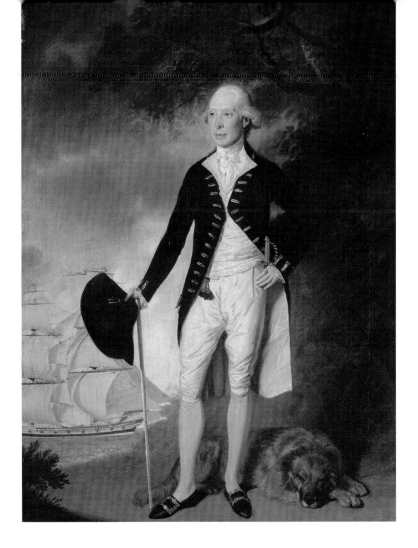

THE ANIMALS

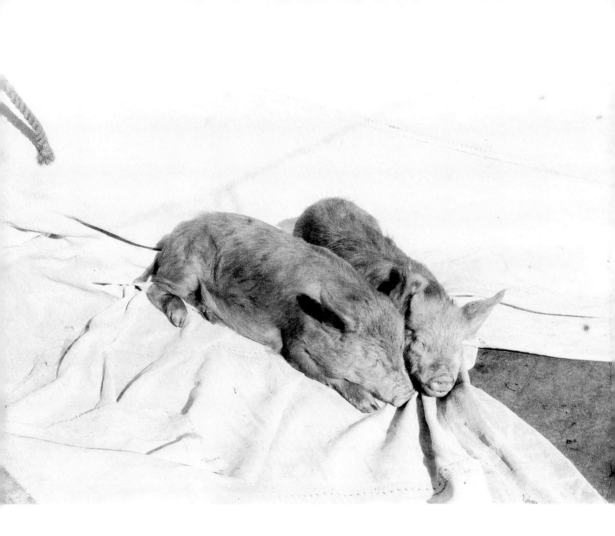

43

Piglets on board the Grace Harwar

The same sea finishing its mad career beneath the fo'c'sle head, drowned the biggest of our three pigs in there — a big fat porker that we had been looking forward to eat. The other two were miserable little things, bought in Wallaroo, and these also would have died had they not been stowed in the bos'n's locker for security.

These lines were written by Alan Villiers, sailor and author, who worked on three large sailing ships that regularly used the Cape Horn route — the *Grace Harwar*, the *Herzogin Cecilie* and the *Parma* — throughout the late 1920s and the 1930s.

44

Swabby

Edward Hutton of the US Navy took his puppy Swabby along in his invasion craft for the Allied landings in France, 6 June 1944. Swabby is wearing a life-jacket specially made by the crew of Eddie's ship.

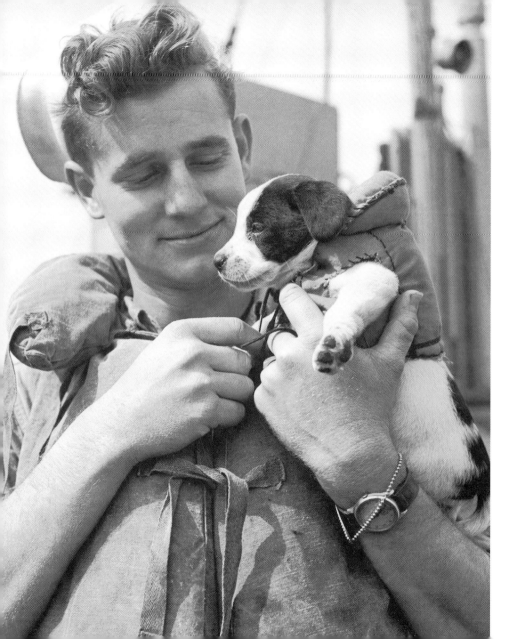

45

Kitten on HMS Aurora, *1914*

The kitten is sitting on the shell tray of a 4-inch Mark IV Quick Firer. HMS *Aurora*, a light cruiser, carried four of these, as well as two 6-inch guns and one 3-pounder anti-aircraft gun. The Quick Firer was a new pattern, semi-automatic gun introduced in 1913, which continued in use in the Second World War and was mounted in such varied vessels as aircraft carriers and trawlers and was even used by coastal batteries. The Marks XII and XXII Quick Firer guns were adapted for submarine use.

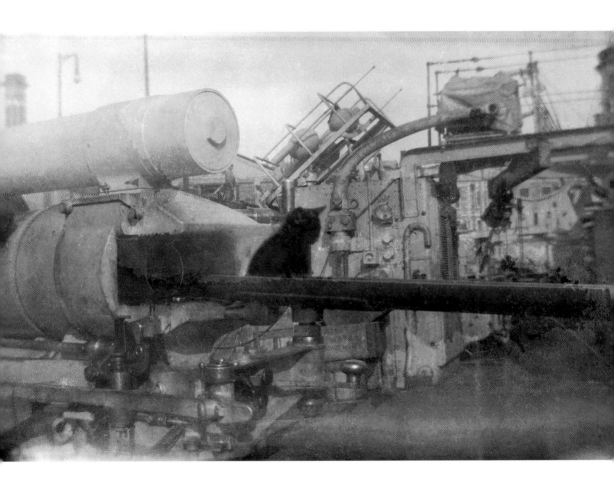

THE ANIMALS

101

46

Cat on board a nineteenth-century troopship

Journals and sketchbooks were often kept on board ship, especially during long voyages, to alleviate boredom. This drawing was one of a series, taken from a sketchbook by Major Edward Hovell Thurlow of the Royal Horse Artillery, while on the troopship *Hydaspes* sailing to India in 1865.

47

The Third Burma War, 1886

Burma was annexed to the British Empire in the nineteenth century. The East India Company had seized the coastal province in the First Burma War (1824–26), lower Burma in the south was annexed in 1852 and the rest of the country in 1885–86. This drawing from *The Illustrated London News* shows a British amphibious force being moved up the Irrawaddy river in fifty-five river steamers and barges manned by men of the Royal Navy. An elephant is towing bluejackets in an armed launch and a Gardner machine gun can be seen on the right of the picture. Elephants were used extensively throughout the war and the pay of elephant attendants was:

1 Jemadar (sepoy lieutenant) to every 20 elephants – 20 rupees.
1 Mahout (driver) to every elephant – clothing, no rations.

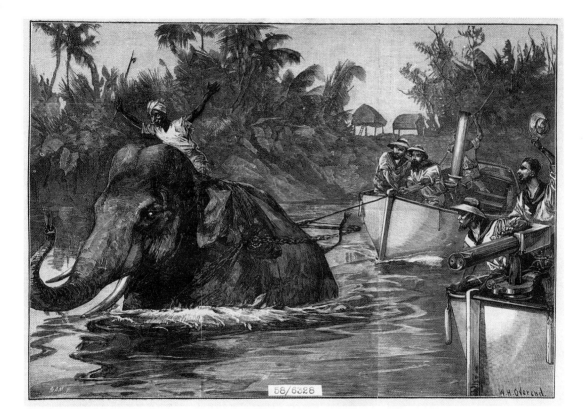

58/6828

W.H.Overend.

THE ANIMALS

105

48

The Prince of Wales's racehorses on board HMS Serapis, 1875

In 1875 the Prince of Wales (later Edward VII) and his entourage sailed to India for a State Visit in the troopship *Serapis*, which was lavishly converted not only to accommodate the Prince but also his horses: the Prince by this time was far too heavy to ride the Arab horses provided by his hosts. Pig-sticking was a popular sport in India, two of the requisites being 'a fast steady horse and a good hog spear'. However, the Prince preferred shooting tiger and a tiger cub was brought back to England after the Prince had shot its mother.

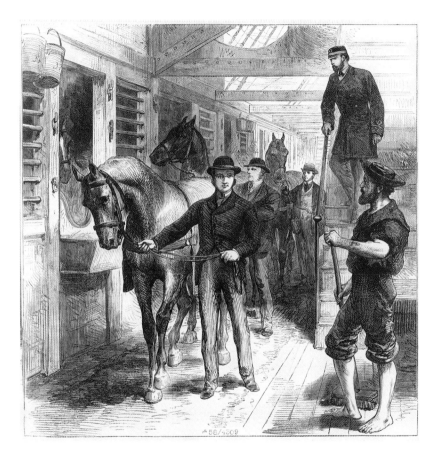

THE ANIMALS

49

Animals on board HMS Serapis, 1876

The Prince of Wales returned from India in April 1876 bring-
ing with him a menagerie of eighty animals. 'The elephants
walked the deck, the deer were very tame and even the tigers
were domesticated though they exhibited tendencies to relapse',
reported *The Illustrated London News*. Prince Louis of Battenberg, the
father of Lord Mountbatten, accompanied the Prince and
sketched many of the animals for *The Illustrated London News*. He
wrote of one of the tigers, 'The beast nearly trod on my toes
and gave me rather a start'. Once in England the animals were
dispatched to London Zoo.

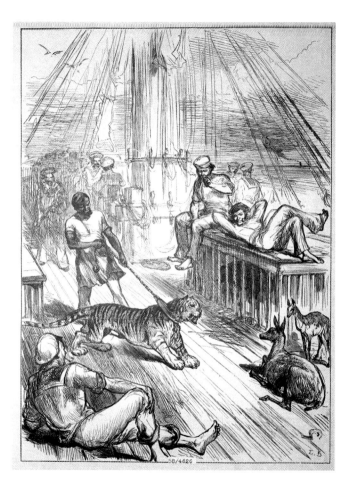

THE ANIMALS

109

50

Poodle on board an unknown yacht, late nineteenth century

Whenever a man is lonely, God sends him a dog.
Alphonse de Lamartine (1790–1869)

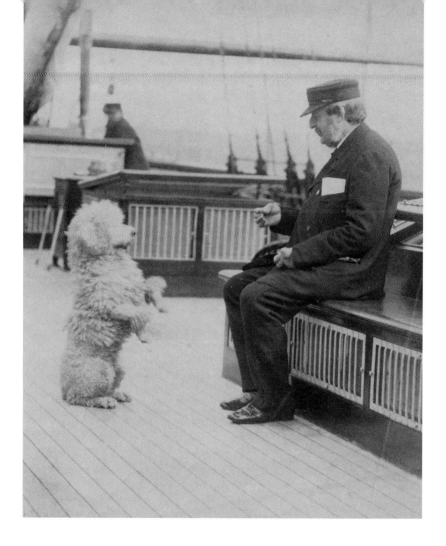

THE ANIMALS

III

BIBLIOGRAPHY

Benstead, C. R., *Round the World with Battlecruisers*, Hurst and Blackett, *c.*1925

Boteler, J. H., *Recollections of My Sea Life from 1808 to 1830*, Navy Records Society, 1942

De Chair, Sir D., *The Sea is Strong*, Harrap, 1961

Hampshire, A. C., *Royal Sailors*, Kimber, 1971

Haws, D., *Merchant Fleets in Profile: The Blue Funnel Line*, TCL, 1984

Jones, G., *Battleship Barham*, Kimber, 1979

Keppel, Sir H., *A Sailor's Life under Four Sovereigns*, Macmillan, 1899

Knight, E. F., *The Harwich Naval Forces*, Hodder and Stoughton, 1919

Lambton, A., *The Mountbattens, The Battenbergs and Young Mountbattens*, Constable, 1989

Newby, E., *Learning the Ropes: an Apprentice in the Last of the Windjammers*, Murray, 1999

Newman, N. and Tarrant, G., *The Dog Lover's Coffee Table Book*, Collins, 1982

Pelly, Sir H., *300,000 Sea Miles: an Autobiography*, Chatto and Windus, 1938

Pleshakov, C., *The Tsar's Last Armada*, Perseus Press, 2002

Rawson, G., *Nelson's Letters*, Dent, 1960

Rees, J., *The Life of Captain Robert Halpin*, Dee-Jay, 1992

Shaw Baker, P., *Animal Heroes*, A & C Black, 1933

Sisson and Steyn, *Just Nuisance*, Flesch, 1985

Smith, P. C., *Hit First, Hit Hard, HMS Renown 1916–1948*, Kimber, 1979

Strabolgi, Lord, *The Battle of the River Plate*, Hutchinson, 1940

Villiers, A., *By Way of Cape Horn*, Bles, 1930